ANDERS PETERSEN SOHO

PHOTOGRAPHS BY
ANDERS PETERSEN
SOHO LONDON MMXI

THE PHOTOGRAPHERS' GALLERY & MACK

"I wish to create a puzzle of life…
I want to see everything, capture everything,
be a fly on the wall.
But I am not a vacuum cleaner - I choose."

Anders Petersen, 2011

As part of a series of off-site artist commissions organised by The Photographers' Gallery in 2011, we invited Anders Petersen to immerse himself in the subcutaneous hinterland of London's Soho. Turning his direct and unflinching gaze to the street life of this celebrated district, Petersen produced a series of images which are both penetrating in their unremitting focus and sensitive to his subjects. His intimate and diaristic approach to his medium of choice - black and white photography - captures the essence of today's Soho while drawing the viewer back into the depths of its history.

In the last 10 years, Petersen has received numerous invitations for residencies in various cities across the world ranging from Okinawa in 2000, Paris and Rome in 2005, Gap and St Etienne in 2005 and Utrecht in 2007. In each place he spent several weeks, or months, observing the street life, soaking up the atmosphere, getting to know people and ultimately photographing them. He has called these projects his *City Diaries* - visual diaries of cities filtered through Petersen's uncompromising lens. Dense with information, alive to the presence of human and animal flesh, the resulting images consistently suggest a sense of a richly inhabited mental and physical space. Our aspiration was to extend that residency opportunity to London, a city Petersen never had a chance to photograph in.

For one month in 2011, Petersen embedded himself day and night in the life of Soho, documenting the streets, pubs, cafes and private homes of its residents. Exploring the area by foot with his camera, he applied the same forensic intelligence to this subject as he had previously brought to bear on other 'closed communities' such as a psychiatric hospital, an old people's home or a prison.

Petersen's Soho is a testament to the dynamism and diversity of the area and the people who both frequent and live in it. Always curious and prepared to take risks, Petersen seeks out to capture the personalities who inhabit the never-ending cycle of high- and low-life characteristic of this area. Not unlike the painter Lucian Freud, he strips people of all their protective trappings, revealing their vulnerability and individuality and is drawn to exploring the vitality and personality of animals, especially dogs. Through his gaze, mundane objects - chrome taps, a market stall of vegetables, clothing shops - are transformed into things of profound and disturbing beauty.

Petersen's belief is that taking a photograph is first and foremost a personal engagement with the world. Photography is not really a profession for him, it is a state of being. The resulting book is a celebration of Anders Petersen's efforts and his magical ability to get close to the subjects he most cares about.

We would like to thank Anders Petersen for sharing his personal vision of the world with us through his involvement on this project. In realising this body of work, we have relied on the conviction, trust and support of many different groups of people, starting of course with the cooperation from the sitters themselves; on the energy and enthusiasm of Petersen's London-based assistants Nick Kaplony and Thom Bridge, and the curatorial direction of Stefanie Braun (Senior Curator, The Photographers' Gallery). We are delighted to have the opportunity to work on our first collaboration with MACK and wish to thank: Michael Mack for his close involvement in all stages of the book's production; Johannes Frandsen for his excellent work with all the image files; and Greger Ulf Nilson for his beautiful book design.

Bloomberg LP were enthusiastic from the start in supporting the idea of the Soho residency and providing invaluable financial support to make it happen. We would particularly like to thank Jemma Read and Lois Stonock for their commitment to the project. Finally, we would like to thank Ambassador Ms Nicola Clase and her Cultural Affairs Team at the Embassy of Sweden in London for their exemplary support of the work of one of Sweden's most outstanding photographers.

Brett Rogers
Director, The Photographers' Gallery

First Edition
Published by
MACK & The Photographers' Gallery
2012

Photography by Anders Petersen
Edited and designed by Greger Ulf Nilson
Assistant Teitur Ardal
Curatorial direction by Stefanie Braun
Introduction by Brett Rogers
Printed by optimal media

ISBN 978 1 907946 22 6

The project was kindly supported by Bloomberg LP

Bloomberg

The Photographers' Gallery
is a registered charity funded by Arts Council England.
Registered charity no 262548
www.thephotographersgallery.org.uk

www.mackbooks.co.uk

With thanks to Nina Deux Traits, Nick Paravatos & Mairead McHugh, Katie Abbott,
Alicja Wrona, Kevin Bui, Ottilie Wright, Christos Tolera, Mr Ducktail,
Nina Hove, Monika Macdonald, Joakim Kocjancic, Halil Koyutürk, Julia Paramonova,
Athena Meselidou, Melanie Stidolph and Lincoln, Janice McLaren & Pavlov,
Nick Kaplony, Thom Bridge, Karen Stripp, Rowena MacDonald, Mark Cracknell,
Martin Fuller, Kadri Koop, Marian Eespaev, Ginger Blush, Leonid Kocetkov,
Chris Sutton, Diana Choong Forssner, Richard, Michael Mack, Greger Ulf Nilson.
And many thanks to everyone at Blacks.